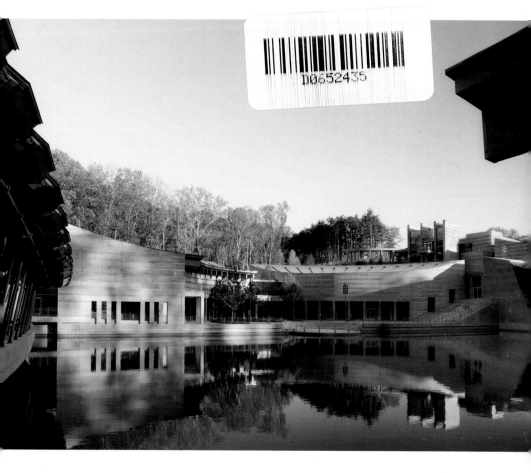

ART IN NATURE

Crystal Bridges Museum of American Art

Crystal Bridges thanks all of those who helped to make our dream—to welcome all to celebrate the American spirit in a setting that unites the power of art with the beauty of nature—a reality.

Crystal Bridges Museum of American Art stands today and for future generations as a testament to the value of a dream, and the power of great art to (literally) move mountains. Thank you.

Contents

The Story of Crystal Bridges

Crystal Bridges was conceived by Alice Walton, daughter of Sam Walton, the founder of retail giant Walmart, and his wife Helen. A long-time art lover and collector, Alice envisioned creating a significant art museum in her hometown of Bentonville, Arkansas, so people of the region would have ready access to great works of art. She planned to build the museum on a 120-acre parcel of natural Ozark forest that had belonged to her family for many years. Alice involved her family in her dream, and the Walton Family Foundation agreed to fund the project.

Builders broke ground for the new museum in 2006. It would be five years before the building was finished, and during those years, the Museum's collection grew and took shape. Alice, with guidance from her advisors, including esteemed art historian John Wilmerding, began to collect in earnest: actively acquiring major works for the new museum. In 2005, their activities drew the attention of the

art world for the first time with the purchase of Asher B. Durand's *Kindred Spirits* from the New York Public Library. Some were critical that the masterpiece would be moved from the city of New York to northwest Arkansas. The newly announced Crystal Bridges was the subject of skepticism and confusion, and Alice Walton herself was characterized by some writers as an art "vulture:" snapping up American masterworks to hide them away in a remote Ozark lair.

The regional community, however, was much more enthusiastic, and embraced the vision. While the city of Bentonville passed a bond issue to provide enhanced civic infrastructure to support the Museum, locals eagerly watched construction progress from on overlook deck erected on the newly opened Crystal Bridges Trail. On November 11, 2011, the Museum opened to an excited public after a gala ceremony on the Bentonville downtown square.

Towering tulip trees are among the native species that populate Crystal Bridges' grounds.

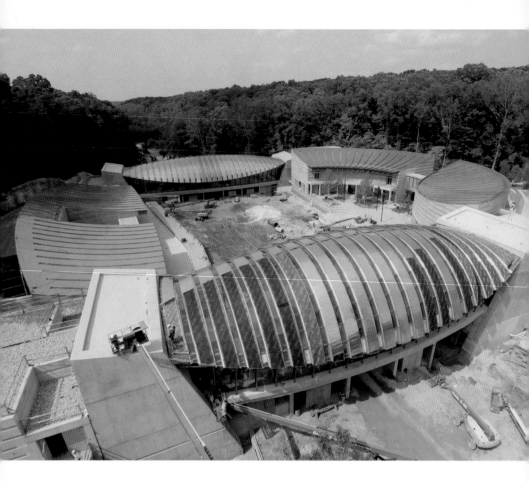

A view of the Museum under construction.

By the end of the first year, Bentonville and Crystal Bridges Museum of American Art had welcomed more than 650,000 visitors, from every state in the nation, and many nations worldwide.

Crystal Bridges Museum of American Art is the first new museum dedicated to American art in more than a generation. By design, Crystal Bridges is a remarkable museum: in its collection, which spans five centuries of American art; in its dramatic architecture; in its lush natural setting; and in its geographical location in the heart of the country, far from any coastal metropolis. These elements make the Museum distinctive among its peers, but the spirit of Crystal Bridges runs deeper. From its beginning, Crystal Bridges has been guided by certain key principles: the Museum offers the finest examples of American art available, holds education at the very core of its mission, and strives to be a welcoming and inspirational place for all people.

This is one of the reasons it was essential that Crystal Bridges be located here, in Bentonville, Arkansas, surrounded by the beautiful Ozark landscape, where the citizens of the region—for whom most of the country's finest museums were once hundreds of miles away—can experience great works of art as part of everyday life, and where visitors from anywhere in the world can enjoy American art amid the beauty of the American landscape. At Crystal Bridges, we share a belief that art is at the center of what it means to be human. Art, like the beauty of our natural world, should be accessible to everyone.

We invite you to experience Crystal Bridges and hope that you make discoveries here that delight your eye, open your mind, and inspire you to dream big ... and maybe do something remarkable.

Welcome to Crystal Bridges!

Top: Early Twentieth-Century Art Gallery

Bottom: A view from beneath Mark di Suvero's monumental sculpture *Lowell's Ocean,* on the Museum's north lawn.

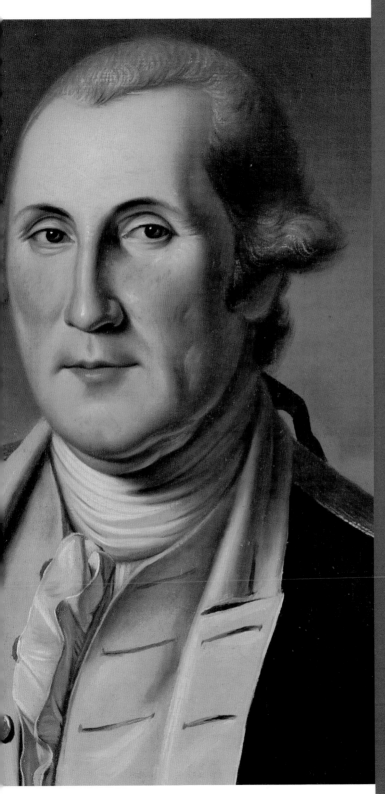

Collection

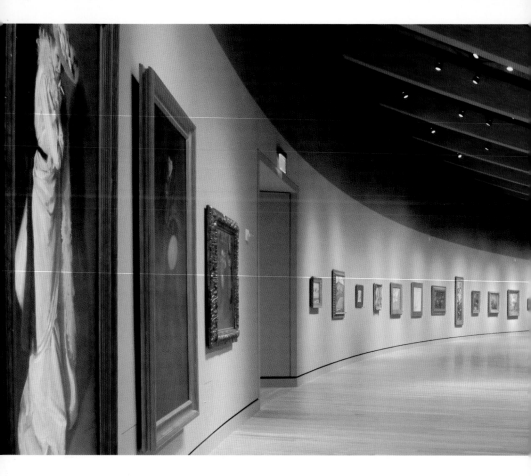

Curved walls provide a
unique point of view in the
Early Nineteenth-Century
Art Gallery.

Crystal Bridges' collection spans five centuries of American art, featuring masterworks by artists from Colonial times through today. The collection on view is arranged chronologically, providing guests with an overview of both the art and the history of America. Works are also arranged to allow guests to see the development over time of certain techniques and styles, with an emphasis on uniquely "American Moments" when American art differed significantly from European art.

"All works of art, when they are made, are contemporary," said Executive Director Don Bacigalupi. "And all contemporary art is informed by what comes before. One of the benefits of having both a historical collection and a contemporary collection is finding ways of linking those two." Throughout the Crystal Bridges galleries, guests witness certain themes emerging: the powerful impact of nature on American artists; the evolving role of women, both

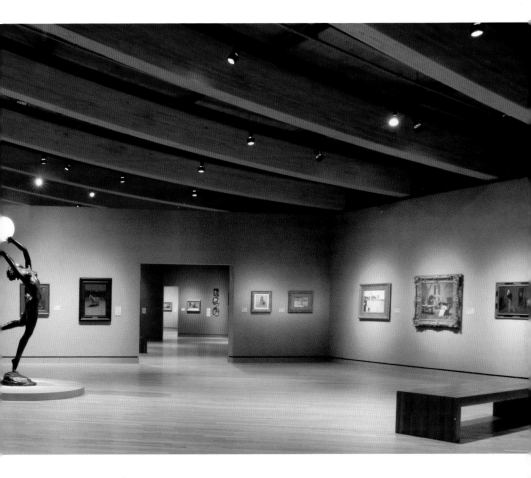

as subjects and artists. The most powerful and important links between the works, however, will be individual discoveries made by Museum visitors as they move through the galleries and experience the collection for themselves.

"There are at least three levels at which a great work of art must operate," explained Bacigalupi. "First is visual engagement, the delight in the eye. This is what draws you to a work of art, the first level of engagement. The second layer might be the intellectual engagement, the meaning embedded in the work. There may be an issue that's addressed, or a theme that's being discussed or debated in the work. The third layer is much more elusive. This is this emotional content, or the work's appeal to the heart. In the greatest works of art, the ones that really sustain themselves over time and really are works for the ages, evidence all three of these functions at work: the eye, the mind, and the heart."

Colonial to Early Nineteenth-Century Art

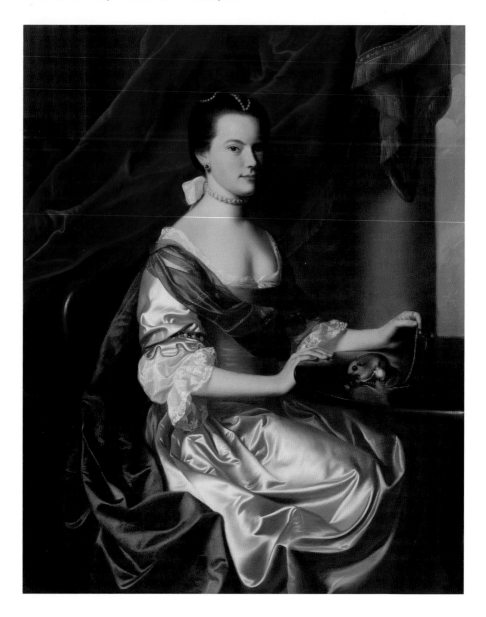

John Singleton Copley
1738–1815
Mrs. Theodore Atkinson Jr.
(Frances Deering Wentworth)
1765
Oil on canvas
51 x 40 in. (129.5 x 101.6 cm)

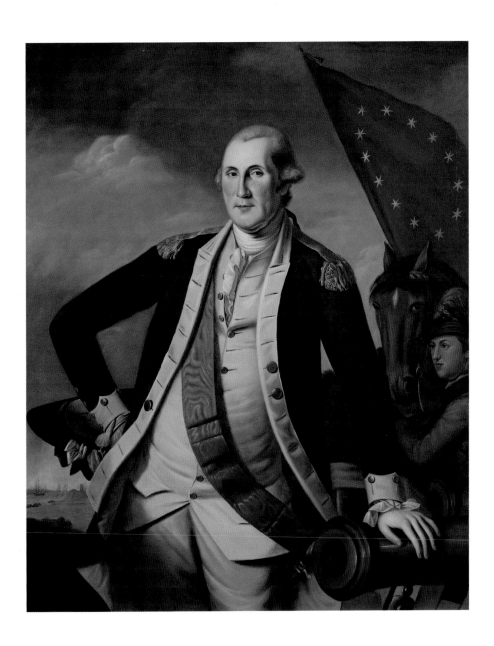

Charles Willson Peale
1741–1827
George Washington
ca. 1780–1782
Oil on canvas
50 x 40 in. (127 x 101.6 cm)

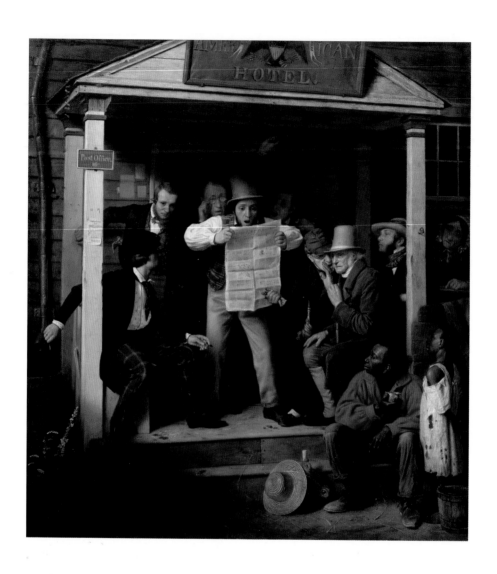

Richard Caton Woodville
1825–1855
War News from Mexico
1848
Oil on canvas
27 x 25 in. (68.6 x 63.5 cm)

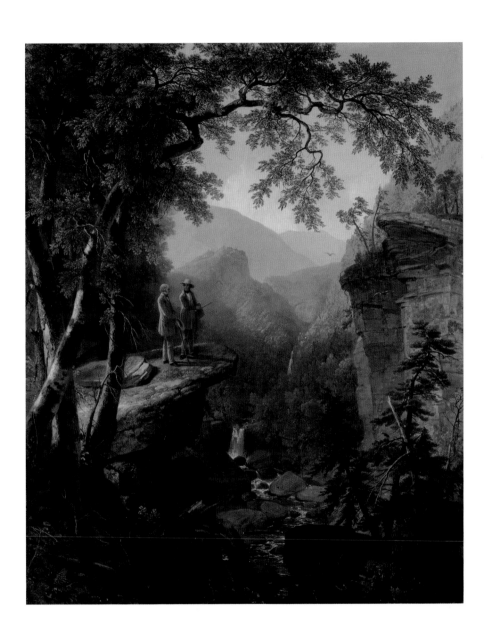

Asher Brown Durand
1796–1886
Kindred Spirits
1849
Oil on canvas
44 x 36 in. (111.8 x 91.4 cm)

Martin Johnson Heade
1819–1904
Haystacks
ca. 1871–1875
Oil on canvas
10 x 22 in. (25.4 x 55.9 cm)
Promised Gift

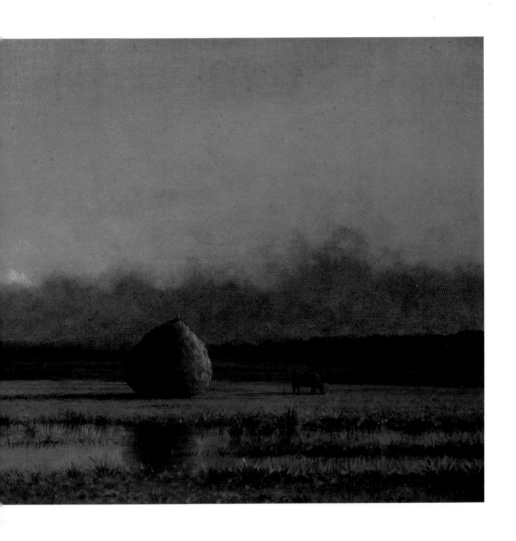

Late Nineteenth-Century Art

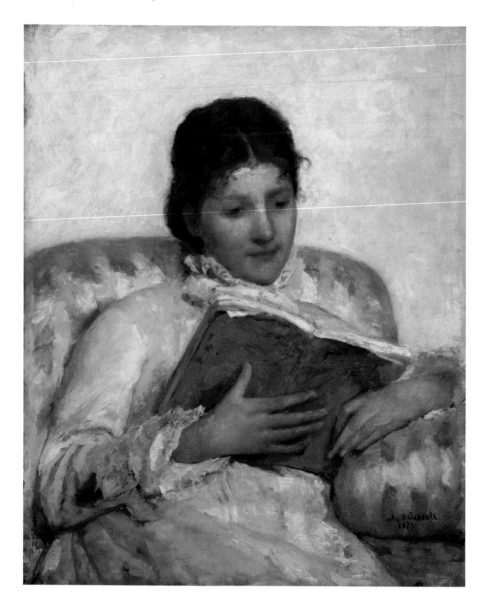

Mary Cassatt
1844–1926
The Reader
1877
Oil on canvas
32 x 25 1/2 in. (81.3 x 64.8 cm)
Promised Gift

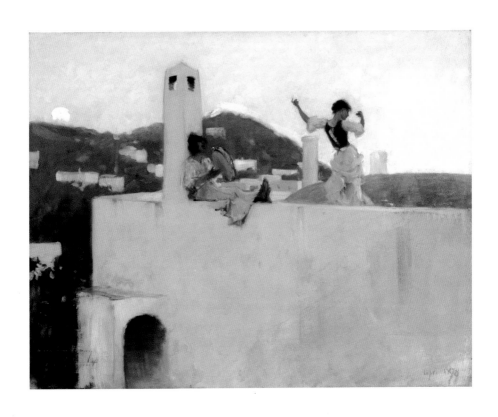

John Singer Sargent
1856–1925
Capri Girl on a Rooftop
1878
Oil on canvas
20 x 25 in. (50.8 x 63.5 cm)

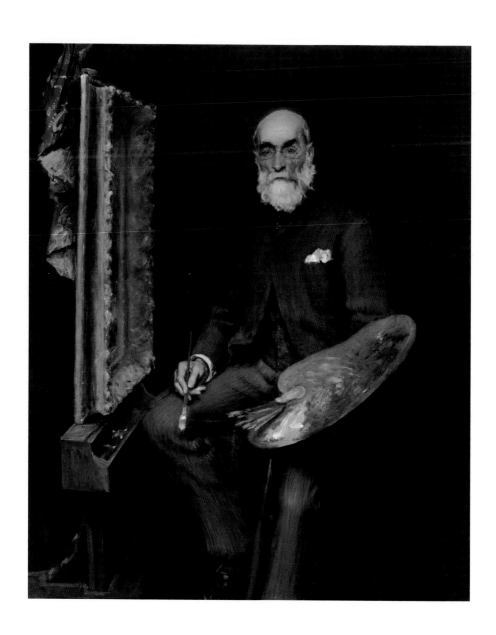

William Merritt Chase
1849–1916
Worthington Whittredge
ca. 1890
Oil on canvas
64 1/2 x 53 1/4 in. (163.8 x 135.3 cm)

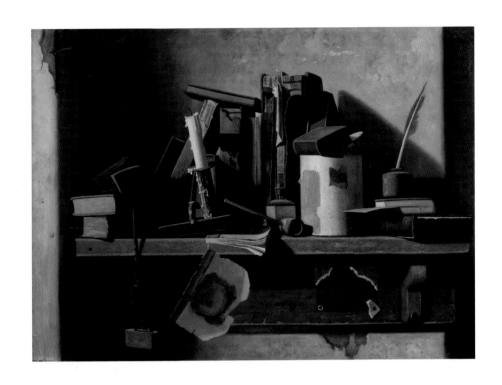

John Frederick Peto
1854–1907
Old Companions
1904
Oil on canvas
22 x 30 in. (55.9 x 76.2 cm)

Early Twentieth-Century Art

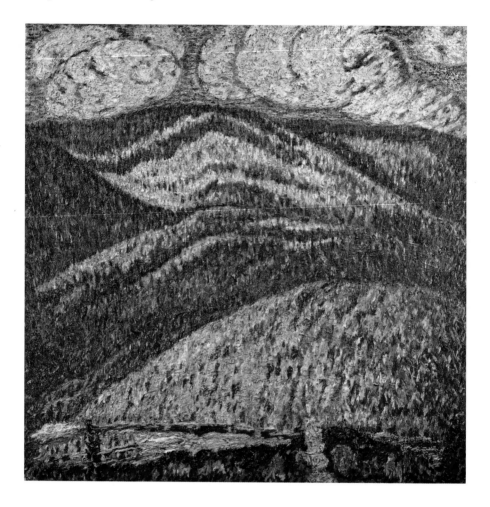

Marsden Hartley
1877–1943
Hall of the Mountain King
ca. 1908–1909
Oil on canvas
30 x 30 in. (76.2 x 76.2 cm)

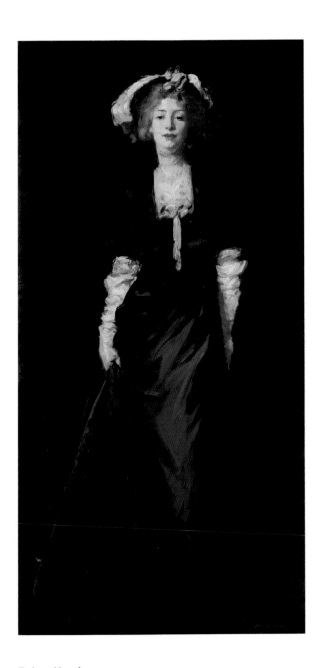

Robert Henri
1865–1929
Jessica Penn in Black with White Plumes
1908
Oil on canvas
77 x 38 in. (195.6 x 96.5 cm)

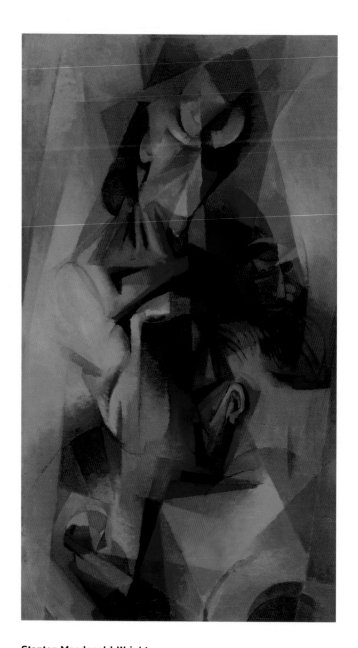

Stanton Macdonald-Wright
1890–1973
Au Café (Synchromy)
1918
Oil on canvas
50 x 28 in. (127 x 71.1 cm)
Promised Gift

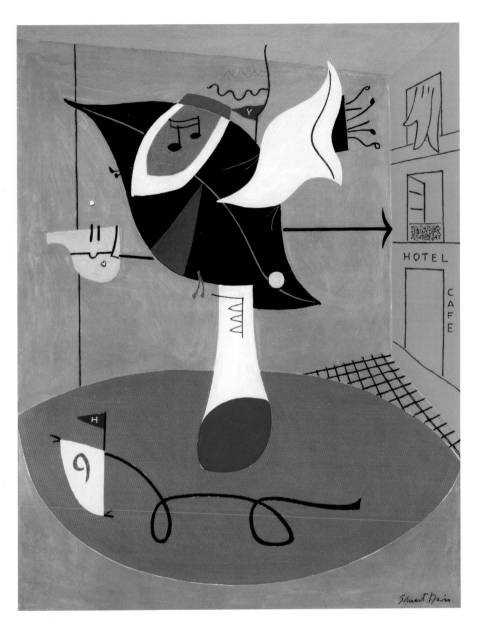

Stuart Davis

1892–1964

Still Life with Flowers

1930

Oil on canvas

40 x 32 in. (101.6 x 81.3 cm)

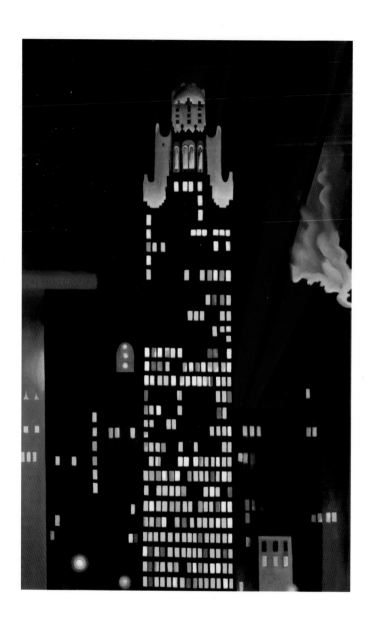

Georgia O'Keeffe
1887–1986
Radiator Building—Night, New York
1927
Oil on canvas
48 x 30 in. (121.9 x 76.2 cm)
Alfred Stieglitz Collection, Co-owned by Fisk University,
Nashville, Tennessee, and Crystal Bridges - Museum of
American Art, Inc., Bentonville, Arkansas

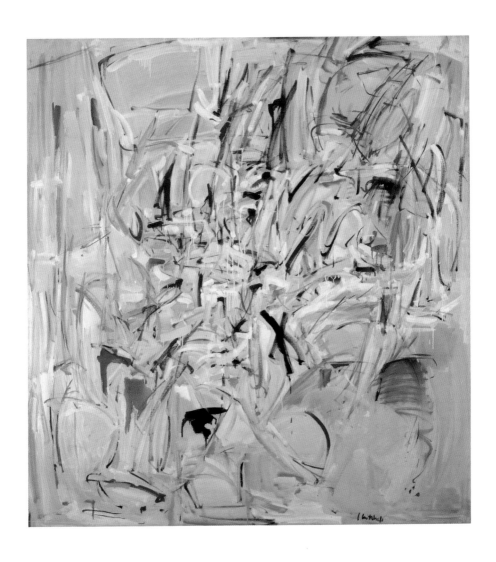

Joan Mitchell
1925–1992
Untitled
1952–1953
Oil on canvas
77 1/2 x 71 1/2 in. (196.9 x 181.6 cm)
Promised Gift

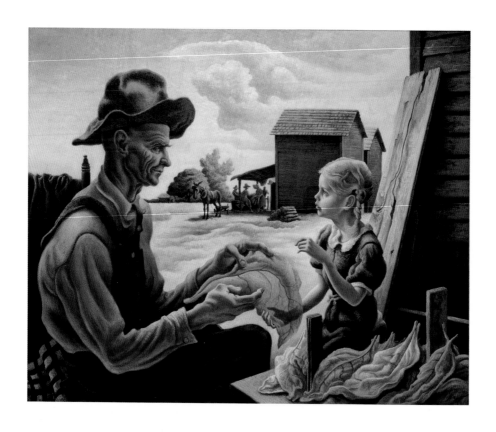

Thomas Hart Benton
1889–1975
Tobacco Sorters
1942/1944
Tempera on board
30 1/8 x 36 in. (76.5 x 91.4 cm)

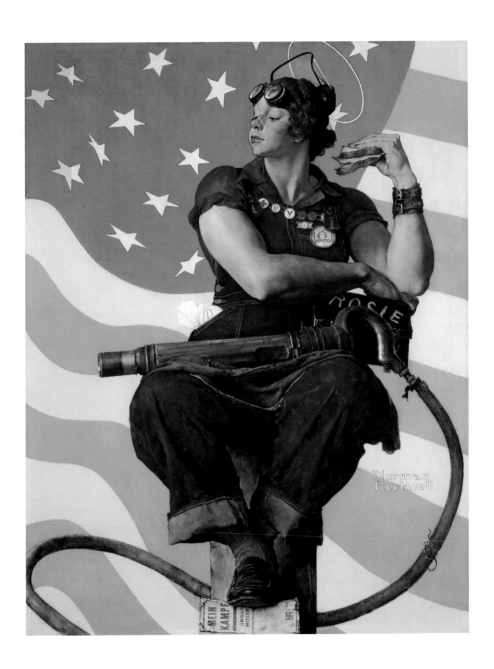

Norman Rockwell
1894–1978
Rosie the Riveter
1943
Oil on canvas
52 x 40 in. (132.1 x 101.6 cm)

Late Twentieth-Century Art

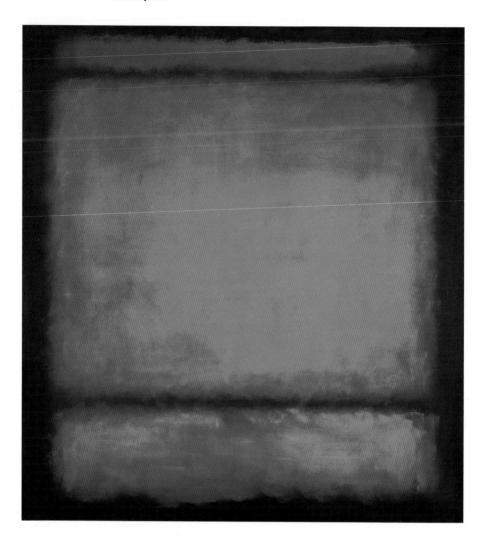

Mark Rothko
1903–1970
No. 210/No. 211 (Orange)
1960
Oil on canvas
69 x 63 in. (175.3 x 160 cm)

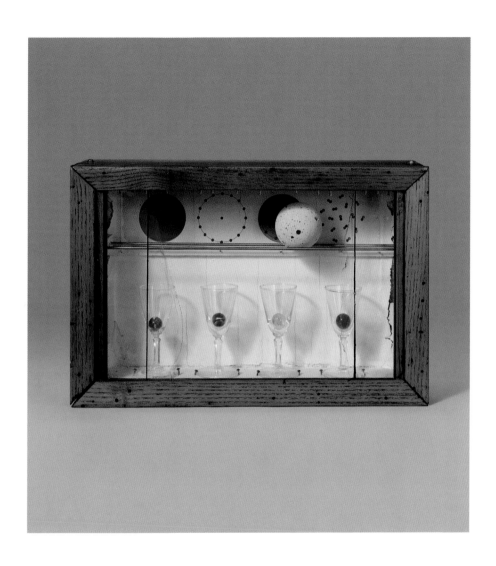

Joseph Cornell
1903–1972
The Birth of the Nuclear Atom
ca. 1960
Wood box construction: glass, gouache,
metal, cork, and printed-paper collage
9 3/4 x 15 x 3 3/4 in. (24.8 x 38.1 x 9.5 cm)
Promised Gift

Adolph Gottlieb
1903–1974
Trinity
1962
Oil on canvas
80 x 185 in. (203.2 x 469.9 cm)

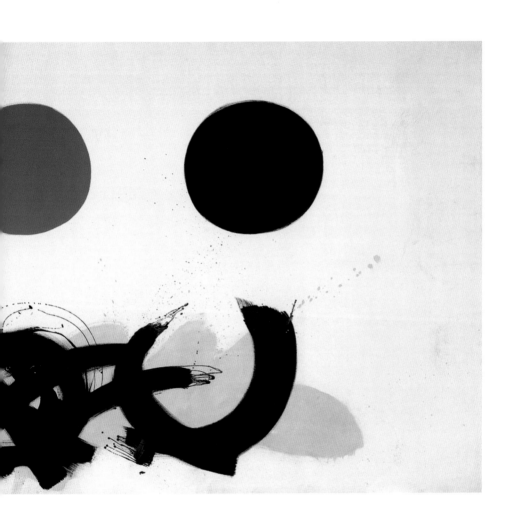

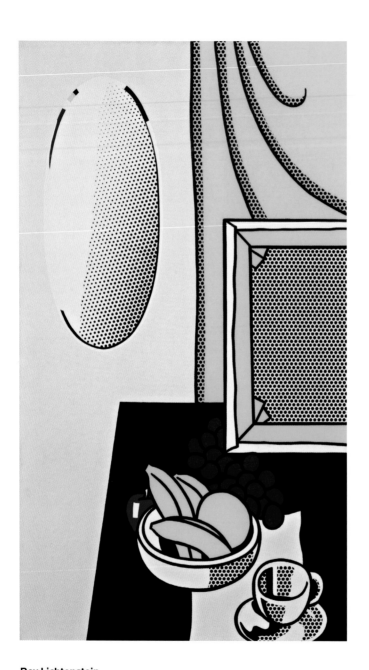

Roy Lichtenstein
1923–1997
Still Life with Mirror
1972
Oil and acrylic on canvas
96 1/2 x 54 in. (245.1 x 137.2 cm)

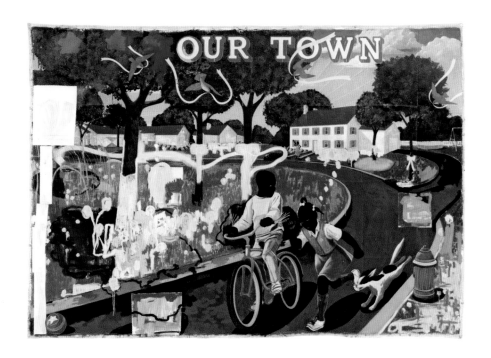

Kerry James Marshall
b. 1955
Our Town
1995
Acrylic and collage on canvas
100 x 142 in. (254 x 360.7 cm)

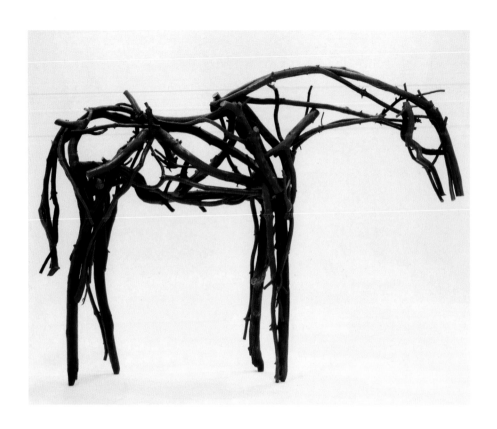

Deborah Butterfield
b. 1949
Redstick
2007
Bronze
91 x 123 x 28 in.
(231.1 x 312.4 x 71.1 cm)

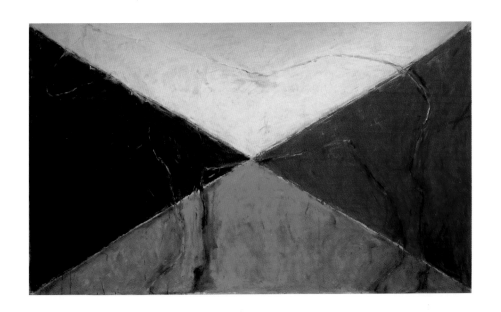

Susan Rothenberg
b. 1945
Four Color Horse
1976
Acrylic and flashe on canvas
67 x 112 in. (170.2 x 284.5 cm)

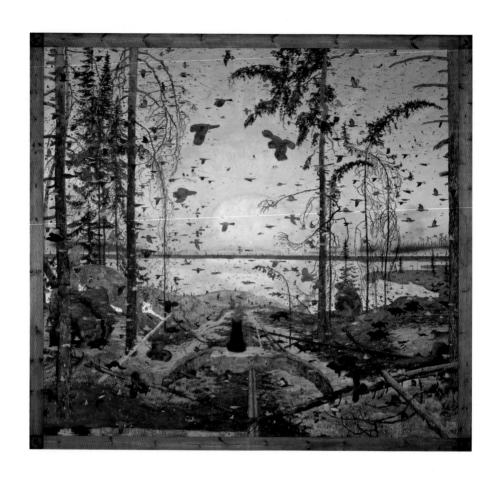

Tom Uttech
b. 1942
Enassamishhinjijweian
2009
Oil on canvas
103 x 112 in. (261.6 x 284.5 cm)

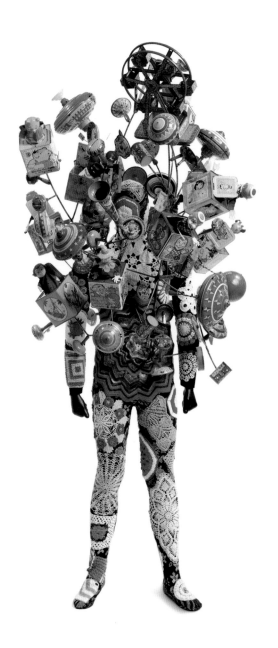

Nick Cave
b. 1959
Soundsuit
2010
Appliquéd found knitted and crocheted
fabric, metal armature, and painted
metal and wood toys
97 x 48 x 42 in. (246.4 x 121.9 x 106.7 cm)

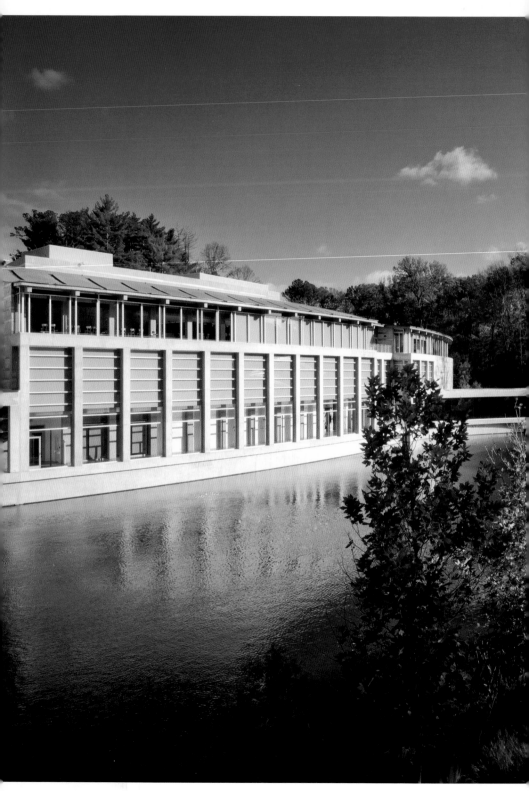

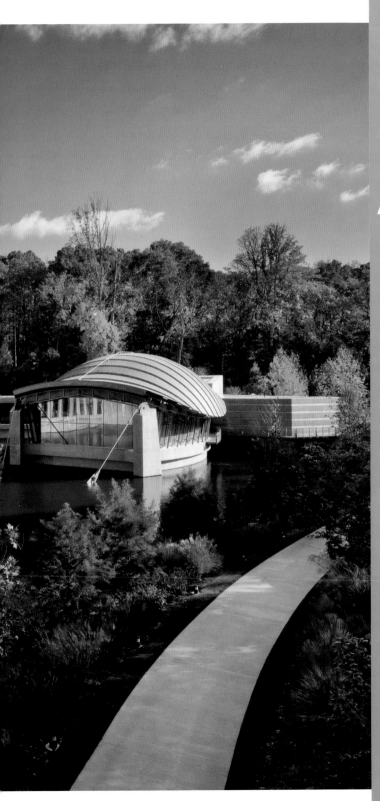

Architecture

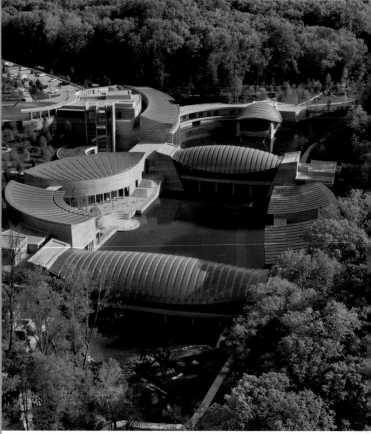

Moshe Safdie—Architect
Safdie was born in Haifa, Israel, in 1938. In 1967, Safdie made his architectural debut in Montreal for Expo '67 where he designed the critically acclaimed and groundbreaking urban housing project, Habitat. Safdie and his design firm have designed projects around the world, including museums, cultural centers, libraries, hotels, and airports.

Safdie has also made significant contributions to education through his teaching at Yale, McGill, and Ben Gurion Universities. From 1978 to 1989 he served as director of Harvard's Urban Design Program and as Professor of Architecture and Urban Design. His many awards include the Gold Medal of the Royal Architectural Institute of Canada.

The Building

Nestled at the base of a natural ravine in the heart of the Ozark forest, Crystal Bridges was designed to be both a complement and a counterpoint to the surrounding landscape. Rather than building at the edge of the ravine, overlooking the stream below, Safdie chose to let the landscape embrace the building, and make the spring water an integral part of the design. Two ponds were created with a series of weirs that manage the inflow from Town Branch Creek and nearby Crystal Spring. This natural spring, along with the striking glass and copper bridges that span the ponds, provided Crystal Bridges with its name.

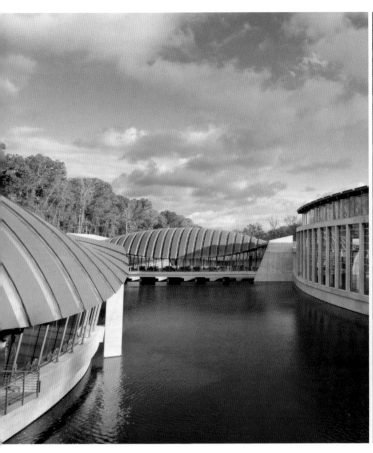

The contrast of poured concrete walls and red cedar trim, brushed steel railings and soaring pine beams suggest the uniquely human ability both to manipulate and be inspired by our environment. The arched roofs of the bridges for which it is named give the Museum the aspect of a mammoth geological formation, born of the earth itself. This combination of nature and design is at the core of the Museum—both its physical form and the philosophy that guides it. A tribute to American culture and history through its art, Crystal Bridges is also a tribute to the land itself, and a celebration of how the landscape has helped to shape the character and history of America's art and its people.

Opposite: An aerial view reveals the Museum's bridge architecture.

Above left: Nestled at the base of the ravine, Crystal Bridges buildings are surrounded by the forest on all sides.

Above: Architectural concrete, banded in red cedar echoes the natural colors of the environment.

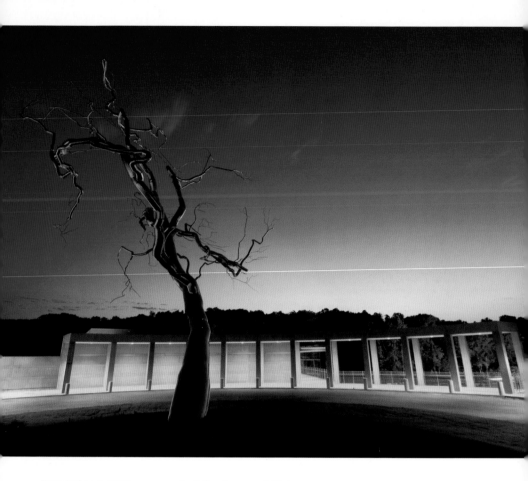

Roxy Paine, b. 1966
Yield, 2011
Stainless steel
47 ft 6 in x 45 ft
(1447.8 x 1371.6 cm)

Architecture and Nature

Throughout the museum, Safdie's design gently reminds visitors of the building's beautiful natural setting. Construction materials were chosen to complement the colors occurring in the landscape: including natural woods, and copper roofs that oxidize over time, acquiring the brown patina of an old penny. Throughout the Museum, windowed interior reflection areas frame unique views of the landscape and provide an opportunity for guests to pause and refresh between galleries.

The approach to Crystal Bridges is understated: a winding road through the forest introduces guests gradually to the Museum's façade, which appears at first as a simple colonnade. The full impact of Crystal Bridges architectural presence is not felt until guests draw close enough to get a glimpse into the ravine at the grander structures revealed below. Standing at the edge of the ponds on Walker

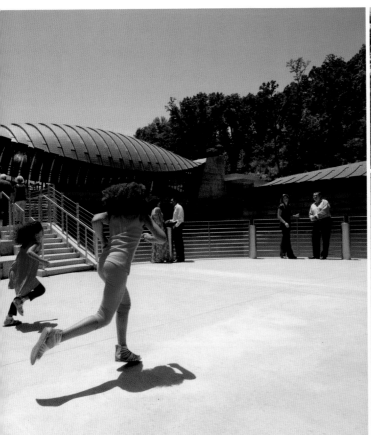

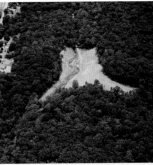

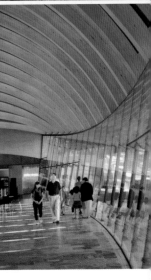

Landing, at the heart of the Museum complex, guests find themselves encircled by Safdie's powerful architecture, crowned above by towering native trees on all sides.

Preservation of the museum's natural landscape was paramount, and great pains were taken to ensure that construction disrupted as little of the site as possible. A narrow six-foot easement was adhered to between the construction zone and the forest to preserve the trees. Aerial views of the clearing before construction show how closely the cleared area matches the Museum's final footprint. Much of the timber from the trees lost during construction was preserved, and has been used to provide benches in the Museum's galleries, as well as frames and turned-wood artworks by local artists, available in the Museum Store.

Above left: Walker Landing provides an outdoor gathering place and views of the Museum's lower pond.

Above top: An aerial view of the minimal clearing done prior to construction of the Museum.

Above bottom: The curved ceiling beams and floor-to-ceiling windows in Eleven give the Museum's restaurant bridge an open, airy feel.

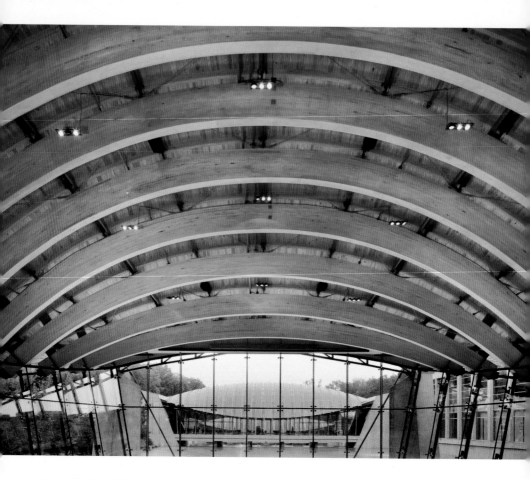

Building Bridges

One of the trademark features of Crystal Bridges'
architecture is the curved roofs of the bridges and Great
Hall. These are genuine suspension structures, though not
quite the same as traditional suspension bridges. Rather
than supporting the floor, these cables support the roofs
and glass walls. The floors are supported on piers below.
Once the cables were anchored in place, the massive
glue-laminate pine beams that rib the interior ceilings were
attached to the cables, giving the roofs their distinctive
shapes. With the roofs complete, the glass walls were
installed, their weight fully supported by the roof and cable
structure. Special flexible joints were designed to connect
the glass walls to the ceilings and floors to allow for the
gentle movements of the suspension design.

The glue-laminate pine beams used in the Museum's roofs
were made through a complex process of gluing multiple

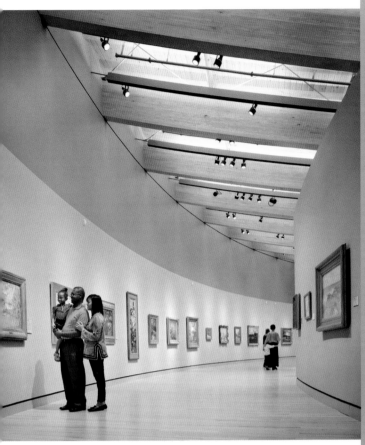

Thelma and Louise
Special arrangements were made for two particular trees on Crystal Bridges grounds. A pair of mature tulip trees, perched on the edge of the bluff to the southeast, were slated for removal. Museum founder Alice Walton was reluctant to lose these elegant specimens, and asked architect Moshe Safdie to make slight adjustments to the shape of the corridor between the main and south lobbies in order to protect the pair. The excavation team made saving the trees a priority, and their roots were carefully nurtured and protected throughout construction. Playfully named "Thelma and Louise" for their precarious cliffside location, these venerable trees were saved, and now serve as the logo for the Museum's restaurant, Eleven. From the trail along the ridge behind the Great Hall, guests can view the cut-out in the building's design that accommodated the trees.

layers of wood together while heating and bending them into shape. The curvature of the beams had to be precise or the roofs would not be stable. The extensive search to find a subcontractor who could handle the difficult task discovered the right vendor here in Magnolia, Arkansas. Though each of the more-than-140 beams had to be manufactured individually, they all fit together perfectly. Not a single beam had to be reshaped or rebuilt.

One striking characteristic of the Museum's architecture is the curvature of many interior gallery walls. This curvature creates sight-lines that make it possible for visitors to view a long array of paintings at once, something that cannot be accomplished in galleries with straight walls. The curve also adds an element of challenge to art installation: hanging large flat pictures on curved walls requires special wall mounts, which were designed by Crystal Bridges' team of professional preparators.

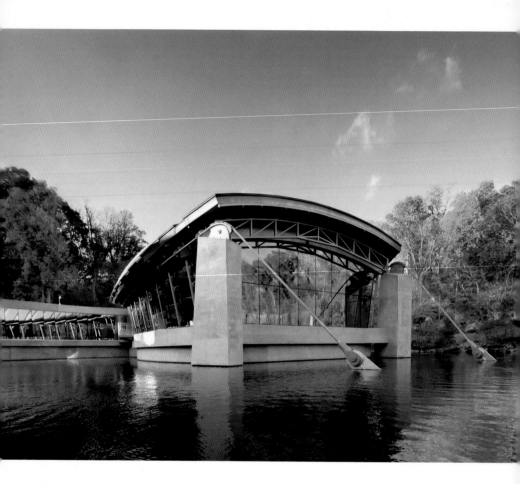

Above: The massive cables supporting the roof and walls of the Great Hall are anchored to piers set into the upper pond.

Opposite: A view of the restaurant bridge from the creek south of the Great Hall.

Water at Crystal Bridges

The pond system at Crystal Bridges is one of the most beautiful signature features of the Museum, and was also one of the most challenging for engineers. The creek that runs through the site is fed by the waters of Crystal Spring and Cindy Spring to the south, as well as by torrents of water that cascade down the steep hillsides in rainy weather.

The challenge of Crystal Bridges' design was to create a way to manage the flow of water in a way that would ensure the long-term safety of the works of art housed in the museum's collection. Weirs under the bridges serve both as dams to create the upper and lower ponds, and as flood-control systems capable of releasing a large amount of water through the ravine quickly when in flood. The labyrinth-shaped walls of the weirs provide enough surface area to release the incoming waters of a 500-year, a 1,000-year, or even a 5,000-year flood, without inundating the Museum galleries or storage areas.

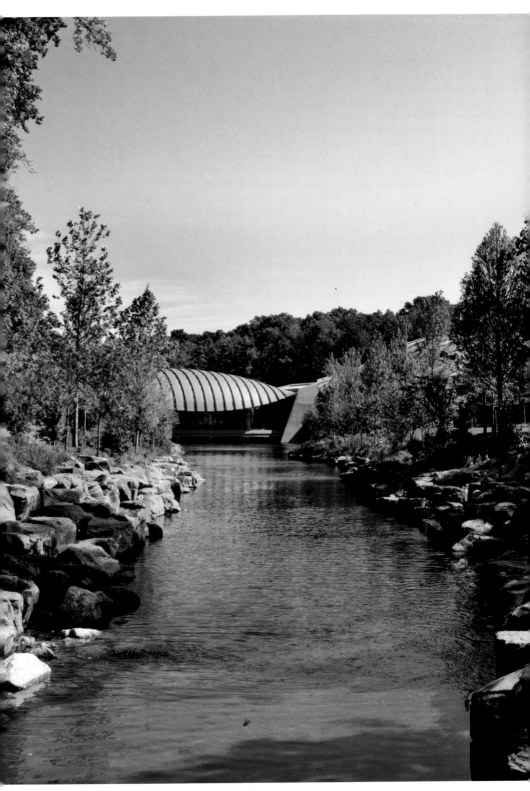

Nature

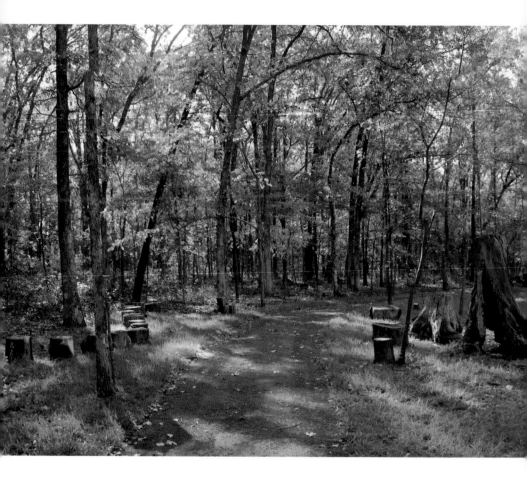

Stumps harvested from trees felled during construction provide a creative play area and seating for educational programming along the Dogwood Trail.

The landscape around the Museum is as much a part of the experience of Crystal Bridges as the artwork inside it. The building was designed to offer visitors periodic views of the forest as "breathing space" between galleries. Access to, and stewardship of, our natural environment is a key element to Crystal Bridges' mission, and informs the institution's overall philosophy—that art and nature are both vital to our human spirit, and should be accessible to all. More than three miles of trails invite guests to explore and appreciate the Museum grounds, and within a few yards of the trailhead, the Museum itself is out of view among the trees, providing a sense of immersion in the forest.

Scott Eccleston, Director of Grounds and Facilities, is responsible for the graceful integration of the Crystal Bridges lawns and landscaped beds with the surrounding forest. More than 250,000 native plants or cultivars have been planted throughout the Museum's grounds, including

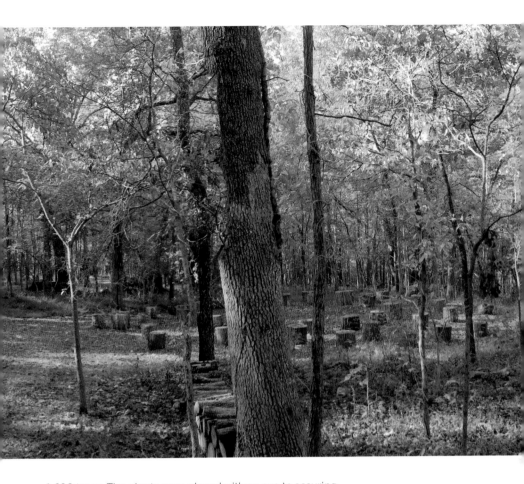

1,600 trees. The plants were placed with an eye to assuring a seasonal display of color and texture—from the surprise of pink dogwoods on the entry drive in the spring, to a line of breathtaking red maples and wildfire blackgum that grace the south lawn in the fall.

An element of play and discovery has also been designed into many of the trails at Crystal Bridges. Alice Walton and her brothers explored and played in these woods as children, and they wanted to share that experience with future generations. In that spirit, Eccelston has adopted a landscape design philosophy he calls "leave no child inside." At locations throughout the grounds, he has designed and built creative play areas to encourage children to explore and enjoy the outdoors. Kids can climb on the massive boulders of Robert Tannen's *Grains of Sand*, explore the waters at Cindy Spring, or hop from stump to stump along one of the "stump walks" built along the Dogwood Trail.

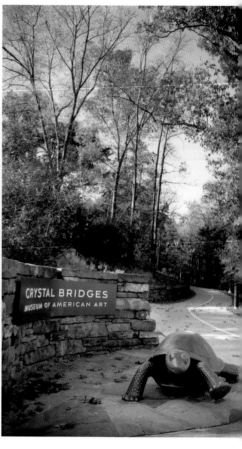

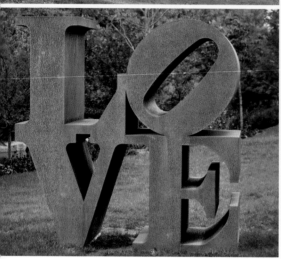

André Harvey, b. 1941
Stella, 2009
Bronze
38 1/2 x 25 1/2 x 67 in.
(97.8 x 64.8 x 170.2 cm)

Robert Indiana, b. 1928
LOVE, 1966-1999
Cor-Ten steel
72 x 72 x 36 in.
(182.8 x 182.9 x 91.4 cm)

Nancy Schön, b. 1928
Tortoise and Hare (detail),
2009
Silicon bronze
Tortoise: 29 x 29 x 60 in.
(73.7 x 73.7 x 152.4 cm)
Hare: 36 x 24 x 29 in.
(91.4 x 61 x 73.7 cm)

The Art Trail

The Art Trail, which connects the Museum's south entrance to the City of Bentonville's Crystal Bridges Trail, is punctuated with sculptures both sublime and whimsical including André Harvey's playful bronze sculpture *Stella* and Robert Indiana's iconic *LOVE*.

The Art Trail also provides access to the waters of Cindy Spring, with a charming bridge that crosses the stream and a children's area to facilitate and encourage outdoor play in a natural setting.

Additional sculptures can be found throughout the Museum grounds and trail system, including Roxy Paine's striking stainless steel *Yield*, located near the main entrance, and a site-specific tribute to the Native Americans who perished on the Trail of Tears, *A Place Where They Cried*, by Pat Musick and Jerry Carr, located on the northern Crystal Bridges Trail.

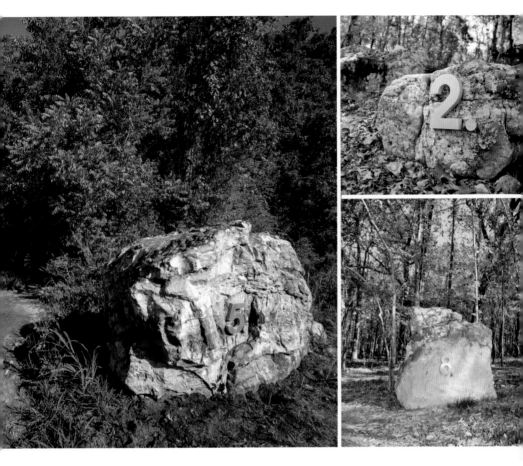

Robert Tannen's *Grains of Sand*

Scattered about the Museum's grounds are fifteen large boulders, each sporting a number, from 1 to 15. These are a site-specific artwork by New Orleans artist Robert Tannen titled *Grains of Sand*. The boulders, harvested from a quarry in the nearby Boston Mountains, resemble the native stone that forms the bedrock of Crystal Bridges' site, and yet they share a distinctive character all their own. The stones encourage visitors to hone their skills of observation, and also to slow down, look around, and take in the beautiful individual locations at which each is sited. The Outside brochure, available in the Museum's lobbies, includes a map identifying the location of all fifteen of the stones.

Robert Tannen, b. 1937
Grains of Sand, 2011
Fifteen boulders with cast aluminum numbers

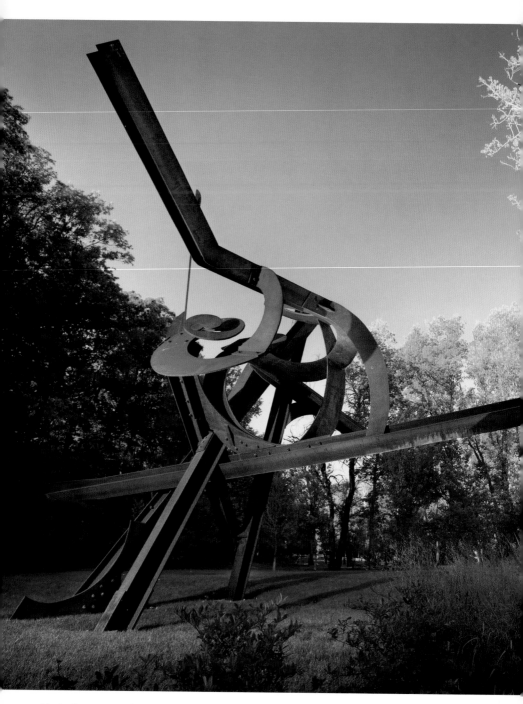

Mark di Suvero, b. 1933
Lowell's Ocean, 2005–2008
Steel
221 ft. 4 in. x 40 ft. 6 in. x
33 ft. 6 in. (650.2 x 1234.4
x 1021.1 cm)

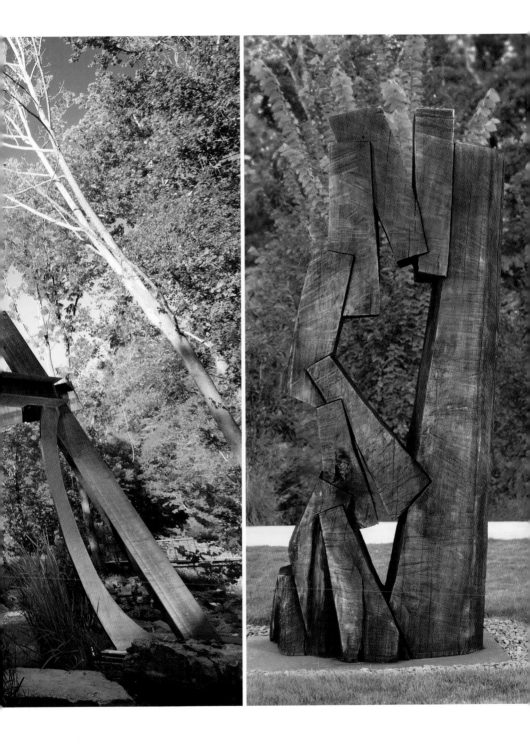

Robyn Horn, b. 1951
Already Set in Motion, 2011
Redwood and black dye
120 in. high (304.8 cm)

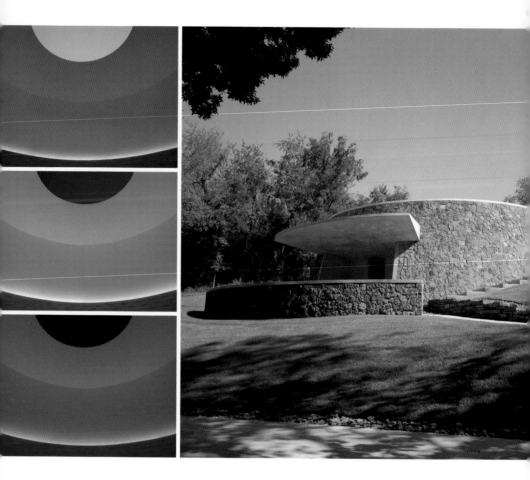

James Turrell, b. 1941
The Way of Color, 2009
Stone, concrete, stainless
steel, and LED lighting
19 ft. x 54 ft. 4 in.
(579.1 x 1656.1 cm)

The Skyspace

The Art Trail is anchored by *The Way of Color,* a Skyspace
installation by artist James Turrell that frames the sky
through a viewing oculus overhead. Each evening, just
before sunset, a computer-programmed LED (light emitting
diode) display colors the ceiling of the chamber in hues
ranging from subtle to dramatic. Through the ensuing 30
minutes, the sky through the oculus seems to appear as
pink, green, violet, or white depending on the changing
interior colors.

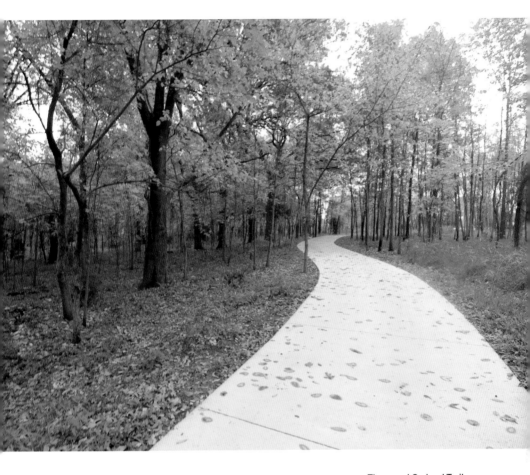

Orchard Trail

The Orchard Trail is a hard-surface walking and biking trail that provides access to Crystal Bridges' main entrance from the Additional Parking lot, Orchards Park and NE J Street. The trail features an evergreen forest made up of several species of pine trees, including one of two Arkansas Champion trees on Crystal Bridges grounds: an eastern white pine that measures 110 inches in circumference and 90 feet tall, with a 40-foot crown spread.

Other signature plants along this trail are passion flower vine, beauty berry, and a host of wildflowers that bloom from spring through mid-summer.

The paved Orchard Trail provides a scenic walk to the Museum's main entrance.

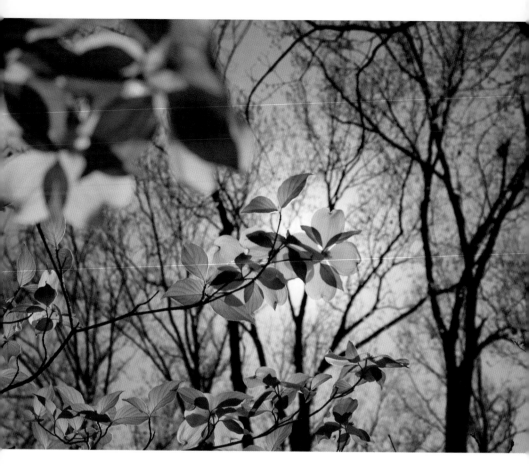

The Dogwood Trail features native species and unique cultivars, offering a long blooming season each spring.

Dogwood Trail

Pedestrian friendly, the mile-long Dogwood Trail is the longest trail on Crystal Bridges' grounds and features more than 500 dogwood trees that burst into spectacular flower in the spring. This trail passes through the eastern part of the Museum grounds—an area that still looks much like it would have to pioneers in the early nineteenth century. In addition to the signature dogwoods, this part of the forest features many large hardwood trees: primarily oak and hickory, as well as spicebush and sassafras plants. A stone bridge along this trail crosses one of two natural springs on the grounds.

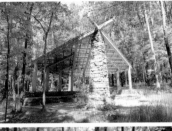

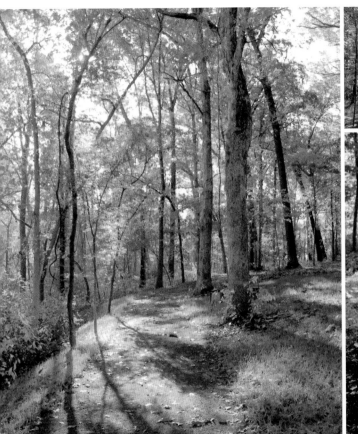

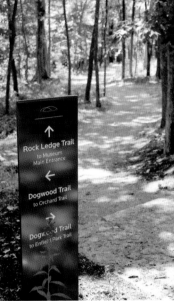

Rock Ledge Trail

The Rock Ledge Trail is a half-mile trail that takes its name from the rock bluffs carved into the hills to make way for a nineteenth-century railroad that was never completed. This soft surface, pedestrian-only trail overlooks the Museum's north lawn, with views of Mark di Suvero's monumental sculpture *Lowell's Ocean*. Plant highlights on the Rock Ledge Trail include serviceberry and wild hydrangeas, as well as several cultivars of native redbud. The trailhead is accessible from Walker Landing via the East Terrace. After climbing the long staircase to the trail, guests may wish to rest at the Rock Ledge Shelter and enjoy the native plants and animals you may encounter. Black squirrels have been seen here, as well as many species of birds.

Above left: The straight, level path of the Rock Ledge Trail reveals its history as a former railroad bed.

Above top: The Rock Ledge Structure is a beautiful space to rest and reflect.

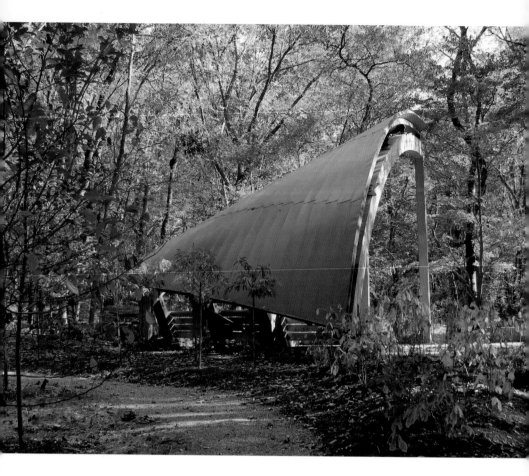

The Tulip Tree Shelter was created from a mock-up of the Great Hall roof structure.

Tulip Tree Trail

The Tulip Tree Trail showcases the dramatic architecture of the forest, and features some of the largest trees on the Crystal Bridges grounds, many 100 feet tall or more. Here, too, guests will see flowering tulip trees and beech trees, both native to Northwest Arkansas.

The lovely Tulip Tree Shelter is located just off the trail. This unusual structure was built as a 1:3 scale model of the unique roof design of the Museum's Great Hall. The area has been planted with an array of native species, including more than 400 trilliums which make their appearance in early spring.

Another highlight of this trail is the second of two Arkansas Champion Trees on the Museum grounds: a black gum tree that measures a mighty 122 inches in circumference and 98 feet tall, with a crown spread of 80 feet.

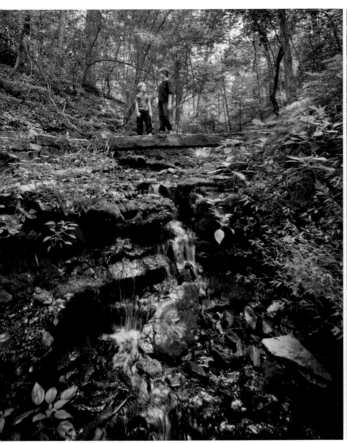

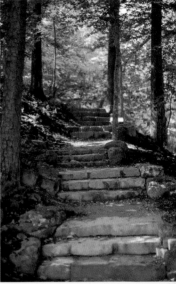

Crystal Spring Trail

Forming a loop from the Tulip Tree Trail, Crystal Spring Trail offers access to the natural spring for which Crystal Bridges is named. Groundskeepers have been careful to preserve the magical quality of this beautiful, hidden spot, where the constant flow of cold springwater carves the limestone into curves and bowls on its way to the pond below.

Maidenhair and Christmas ferns, vinca, and deep green moss are among this trail's signature plants, where native trout lilies and ladyslippers can also sometimes be found. On the southern hillside, the grounds team has restored the gardens of Dr. Neil Compton, who owned the land until the 1970s and indulged his passion for native plants in terraced beds along the steep ravine. Many of the native rhododendrons he planted still bloom there today, and the beds have been replanted with delicate site-specific native plants such as rattlesnake plantain, cohosh and wild ginger.

Above left: Beautiful Crystal Spring is just a short walk from the Museum's south entrance.

Above top: Steps formed of slabs of native stone integrate the Crystal Spring trail with the landscape.

Above bottom: Christmas fern.

CRYSTAL BRIDGES
MUSEUM OF AMERICAN ART

Crystal Bridges Museum of
American Art
in association with Scala Arts
Publishers, Inc.

Text and Photography Copyright
© 2013 Crystal Bridges Museum
of American Art

Book Copyright © 2013 Scala
Arts Publishers, Inc.

First published in 2013 by
Scala Arts Publishers, Inc.
141 Wooster Street, Suite 4D
New York, NY 10012, USA

Scala Arts & Heritage Publishers
21 Queen Anne's Gate
London SW1H 9BU
United Kingdom

Distributed in the booktrade by
Antique Collectors' Club Limited
6 West 18th street, 4th Floor
New York, NY 10011
United States of America

ISBN: 978-1-85759-838-4

Printed in China

10 9 8 7 6 5 4 3 2 1

IMAGE CREDITS